art is

(SPEAKING PORTRAITS)

THE PERFORMANCE IDEAS SERIES

PERFORMANCE IDEAS explores performance that crosses boundaries of all live art forms and media. The series highlights the long-standing editorial commitment of PAJ Publications to bring together the histories of performance in theatre and in visual art for a more expansive vision of artistic practice.

OTHER BOOKS IN THIS SERIES

art is
(SPEAKING PORTRAITS)

GEORGE QUASHA

New York, New York

© 2016 by George Quasha

art is (Speaking Portraits) is published by PAJ Publications, P.O. Box 532, Village Station, New York, NY 10014.

PAJ Publications is distributed to the trade by Consortium Book Sales and Distribution: www.cbsd.com

Publisher of PAJ Publications: Bonnie Marranca

Publication of *art is (Speaking Portraits)* is made possible by the New York State Council on the Arts with the support of Governor Andrew Cuomo and the New York State Legislature.

Library of Congress Cataloging-in-Publication Data

Names: Quasha, George, compiler.
Title: Art is (speaking portraits) / [compiled by] George Quasha.
Description: New York, New York : PAJ Publications, [2016] | Series: The performance ideas series
Identifiers: LCCN 2016011701 | ISBN 9781555541620 (paperback)
Subjects: LCSH: Artists—Interviews. | Art. | BISAC: ART / Subjects & Themes / General. | ART / Reference. | PERFORMING ARTS / Theater / General. | ART / Criticism & Theory.
Classification: LCC NX165 .Q37 2016 | DDC 700.92/2—dc23
LC record available at https://lccn.loc.gov/2016011701

First Edition

Acknowledgments

The author wishes to thank the artists for contributing to the video work **art is (Speaking Portraits)** and this book derived from it. Thanks to the John Simon Guggenheim Memorial Foundation for a Fellowship supporting this project. Special thanks to artist Hannah Beerman for the transcriptions from video; to Sherry Williams, Jenny Fox, Mamta Murthy, Gary Hill, and Russell Richardson for video editorial assistance along the way; and to Susan Quasha for her assistance at every level of this work over the years and particularly for the design and realization of this book. Thanks to Bonnie Marranca for suggesting that our plan to make the **art is** project into books begin in this series.

Contents

Introduction

This is not a book about what art is. It's a book of *saying* what it is, by those who make it—a portrait of emergent discourse. It's the performative dimension of art in the attempt to state its nature— an effort inevitably doomed from the perspective of abstraction and generality so important to much theorist/historicist/critical interest. Yet it's probably an unavoidable effort, whether implicitly or explicitly, and possibly a necessary one from the perspective of making art and of gaining traction in the process. At least that's one working hypothesis, among others, behind the project: speaking portraits, portraits of artists speaking, portraits of speaking. Or: *art* speaking, inasmuch as the original work in video, **art is/ poetry is/music is (Speaking Portraits)**—begun some fourteen years ago and including so far over 1000 artists in eleven countries—was not conceived as documentary, archive, history, curation, or critical valorization, but as art. Art self-reflection.

The original impulse behind the work of video-recording people saying what may reasonably seem impossible to say, was an interest in actual thinking taking place in the moment. We rarely see people actively thinking, as opposed to repeating favorite thoughts, opinions, or personally branded boilerplate. The hypothesis: real thinking is performative in its moment, a singular happening that bears the impress of a self in context, getting a grip on what is ultimately ungraspable *except* as performance. So, what better opportunity than to ask artists to think aloud about the nature of their core life commitment and activity? *My* art in this process is to support the presence of the artist in such a way that she feels unconstrained, free to inhabit a self-true concern and let

it speak. The editorial principle, first in selecting artists to film, was not curatorial as evaluation (representing the "important" artists), but circumstantial and conversational—mainly the artists I encountered and talked with, even when I didn't have particular interest in their work at that point. Then in editing the video for inclusion in the volumes of **art is**, **music is** or **poetry is**, I looked not for the definition of art but for the most engaged and engaging moments of speaking—where the person comes fully and energetically to the surface. It's something that shows in the face, a quality in the eyes and the voice as well as the words.

My aim in the video work—the volumes last about an hour, show in various venues, and end up on the internet—is that viewers be drawn into the singularity of expression, not the abstractions about art. The rapid passage of artists, who just appear as full-screen speaking faces for a few minutes or so, allows no time for reflection and mental debate, but moves energetically forward; it's an ongoing, shifting intensity of presentness. Optimally, one exits the work *less* sure of what art is. Destabilized opinion makes room for what art actually *is* for the artists who make it.

Experience in showing the work over these many years tells me that much of what I intend does happen for many viewers; thousands have viewed it in exhibition and online, many have commented. Can it happen as a book? That's the open question which the present volume aims to explore. For the images, we've chosen what seems to embody the intensity of a peak moment in a single frame; video—recorded under many circumstances far and wide, often on the fly, sometimes with poor available light— is not photography, and visual quality varies. The words spoken are transcribed and of course edited for a small page. Reading is

very different from viewing-listening, and in a sense this book is a translation of fully embodied speaking and an adaptation to text—the "book of the movie." Reading many pages at once, preferably the whole book, will be most like the original.

"Art" here is intermedial with porous boundaries. My one rule has been that the person be able to declare herself an artist, poet, musician, performer, dancer, or whatever fits the extended sense of art for that person. The portrait embodies the speaking of a declared and chosen identity engaged in saying that by which it knows what it is. I've pursued that state as the condition of live thinking in process—art in its performative dimension as speaking itself to another. Moreover, I've thought to discover the point of intersection between the two main current uses of "performative," distinguishing actual art performance from the linguistic model of *what comes to be in the act of making/saying*. Art is only sometimes intended as performance, but arguably art is in some measure always performative in the illocutionary sense, to use J.L. Austin's word—saying as doing, communication that does what it says. What may not be so clear is that speaking to the nature of art is also performative, especially when it's the artist doing it—and doing so on the spot, in front of a very close camera, without special preparation, in the process of rather intense dialogue. Art, as it were, is thinking about itself out loud. Accordingly, I have chosen to foreground the artist's sense of what art is, as against the historian's, the critic's, the theoretician's, as a powerful mode of discourse in its own right—one which is not separate, or not so separate, from art itself, whatever art is!

In the end it's just a word, but a word of enormous power. To assume we know what it means is a grave danger to the mental

freedom necessary to the work of living artists and its reception by living beings. Listening to so many artists, closely and over many years, has taught me further configurative dimensions of performative mind. Close listening/viewing—non-interfering attention— nurtures art, just as it does people, animals, maybe even plants. I would be content if this long-emerging and ongoing project— **art is/poetry is/music is (Speaking Portraits)**—did no more than communicate the evolving state of attention that brought it into being.

I have chosen a range of artists—seventy out of many hundreds—whose activity somehow shows up in the arena of actual performance, very broadly defined. In this small-book frame, seventy came to seem a quorum for presenting the work in the sensuous complexity of its original impact. It could have been another seventy, or many others, and the actual list is not meant as a statement of preference. In my experience the lesser known, even unknown (certainly to me), have been at least equal in power to the artists of acknowledged importance. And that fact *is* part of the work's statement. Together, their work and speaking challenges us to rethink the performative dimension itself.

Note: The continuing volumes of **art is/music is/poetry is (Speaking Portraits)** may be viewed at quasha.com or on vimeo.com. Other expressions of the work appear there under the names **art is/India, art is/East Africa, myth is,** etc.

art is

(SPEAKING PORTRAITS)

Meredith Monk

I really believe that art has the power to heal.

And that doesn't necessarily mean that it couldn't be
something that a lot of people think is very ugly
or the controversial pieces that seem like they're violent;
they seem like they're not obviously so life-affirming.
I basically think that most artists work out of love
and if something that is a very disturbing work
wakes you up in a way,
that's definitely part of the process of life.
I mean pain is definitely part of the process of life.
And I think that ultimately it's a life-affirming process,
and in the world we are living in now,
which is designed to distract, or divert,
and has a lot to do with instant gratification,
commodification, lack of patience,
and lack of depth of involvement or commitment,
I think that art itself, just to experience it,
if the work is immersive and if it is generous work,
is something that is kind of an antidote
to what we are being fed in the culture
and how it affects our minds.

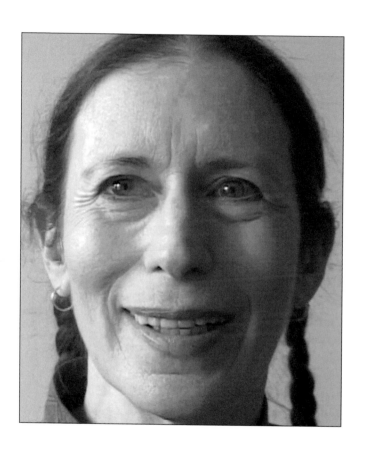

New York, New York: March 30, 2003

Michael McClure

poetry is
a muscular principle
a revolution
for the body spirit
the intellect
and the ear

Oakland, California: November 29, 2007

Marilyn Crispell

It doesn't have to have a reason.
It just is.
It exists from the joy of being.
From the joy of creation.

There are many people who have said this before me, but I feel like
I get out of the way,
and I allow it to come through me
and it can come through me because
prior to that performance I've practiced whatever I need to practice
to be able to do whatever it is
that I need to do
for that to come out.

People often try to categorize music—
is it intellectual, or is it emotional, or is it intuitive?
Well, you can't separate all those and it all comes from the mind,
and the mind is all of those things simultaneously.

Woodstock, New York: July 30, 2002

Eiko Otake

To me art is something beautiful, but in the sense of beauty in its widest extension, the widest recognition. And I feel I'm looking at art when I feel the *intention* of the artist, who is trying to make something beautiful. So it doesn't have to be *my* beautiful, it could be her or his beautiful. And so in that sense it may challenge me in a way that I may not find it beautiful, but I can feel the intention. And if I don't feel the intention, it doesn't quite speak to me. But sometimes at it's best, I'm looking at artwork which may not make sense to me but it's almost like looking out the window, and looking at a whole life, the earth, the time; and all those things come to you without my intention. You know, it is like looking from the window, and then sometimes you see *yourself* in it. And you get "congratulated," you know, the very fact you can *see* yourself in it. Sometimes you don't see yourself in it, but then you see your ancestors—someone you never met, could be a tree, it could be a spirit of many, many lives, and again, from that window you can be looking at something. So to me, that's art.

New York, New York: January 25, 2003

Anthony Braxton

As a young guy, I thought that music was sound.
But after having an experience for almost forty-five years,
I have come to feel that what we call music is a reductionism,
because what's happening is several different planes of radiance
taking place in the space at the same time.
What am I saying? I don't know what music is.
I don't know the face of God.
But I do feel and intuit that the discipline that we call music
is really a transvibrational corridor for a cosmic radiance—
as a way of talking about individual vibrational dynamics.
But that would be only one definition for only one spectrum.
A human being is actually a combination of melodies.
Everything manifest in the universe is music.
It's all around us. And if I reach out to grab it, it won't be it.

It's a spiritual mechanism, part of a tuning system of the universe.
Music is transtemporal. It's past, future, and present.
It's all encompassing. And, in the end, I guess, it's all about love.

I thank the creator of the universe I was able to discover music.
There is no such thing as music. Fuck music.
Yet music is part of the wonder—eye looks at eye looks at eye.
Laughing at the polarities. Music is no different from humor.
It's not there but it's there, and it's always been there.

Bard College, Annandale-on-Hudson, New York: July 11, 2003

Ann Hamilton

I think art is an act of attention.

It can be an act of language,
or it can be an act of material.
It can be an act of listening,
an act of seeing something,
an act of touch.

Art can be material but it doesn't have to be.
I think it's moving from something you know
to something that you don't know
and so art is maybe always
that place of inbetween.

New York, New York: February 16, 2003

Charles Amirkhanian

Poetry is so much larger than most of us think.
It's not just words written on a page to be read to yourself
or to be recited out loud as a kind of declamation.
It also has to do with the word as an object.
I use words in my text-sound compositions or sound poetry
as percussion points.
So that instead of writing pieces for an ensemble of drums,
I have many levels of words spoken in and
out of rhythm at the same time.
So you have

>
> rainbow chug bandit bomb
> bandit bandit
> bandit bandit

and against that you have

>
> bandit chug bandit chug
> rainbow bandit chug bandit chug

And this kind of use of words
where you use them as a sound piece
and you objectify them
makes you listen to them
as if you are a child again.

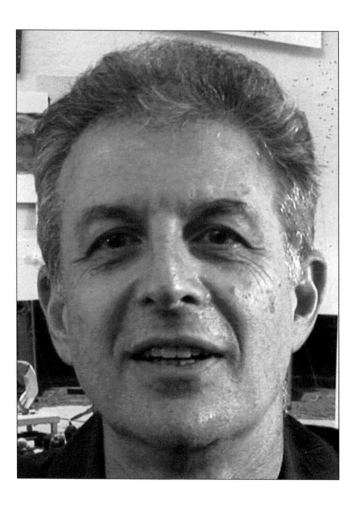

Berkeley, California: November 4, 2007

Mamta Murthy

I believe that art is a research laboratory of our cultures. As an artist I discovered art as I grew older. I realized that it was an extra language that nobody taught me, that I *have*; a way in which I could relate to the world and in which I could find others relating to me in terms of works of art, or just the way somebody put two or three things together—it's art. Sometimes I find myself *using* art, and sometimes I find that art sort of comes out—it's not within my control. It's not like a remote control that you try, that seems to go on every kind of consumption pattern that has come to be today. Art becomes a way in which I sometimes distance myself from what's happening, or sometimes I try and relate to what is happening, especially in terms of protest in India. There are a lot of things happening where I find myself a little weak as a *person* but strong as an *artist*, because I have art, because I have a language; somehow it seems more coherent when I have art by my side. But I also find art being a sort of veil that I use to distance myself from what's happening, because there's a lot of cruelty and a lot of injustice that I see happening, which I am inherently a part of. And a lot of it I'm not able to relate to without something really going drastically wrong with me, and that's when art is useful. When it gives me a bit of distance, gives me craft; it takes me to another sort of plane where I can express myself with sanity.

Biennial of Moving Images, Saint-Gervais, Geneva, Switzerland: November 10, 2003

Will Alexander

A poet of course hears first—
he or she sees later—
but hearing is the balance point.
You have to have an ear for all the sensitivities of nuisance.
We're talking about sonic intelligence: the words do have to balance
where there is continuous flow; there's no hesitation in the sound.
Therefore, phonemes, large words, all need to be understood
within the context of the writing itself. It's never superimposed.
It's like the way plants grow—they come from the inside out.
That's the way language has to work for me, from inside out.
So, this is an alchemical combustion that transpires over time.
Poetry, creativity, is a flow; it's like a mantra, like listening to a raga.
Insistently all throughout, as you walk, as you talk, as you sleep.
It's akin to a yoga, a yoga of language.
So I'm never out of it, never, there're no breaks for me.
Yet it doesn't always appear as a poem or an essay or a play,
but it's like feeling a drone inside of you all the time.
Coltrane talked about that drone, that he got from the band
when he recorded *Africa Brass*, that big drone in the sound,
and you can feel the drone, you know, coming through.
It's a primal transmitter—the *original* transmitter and language.
Someone had to name a tree or a star or a fish or a blossom—
it had to be done, and that's like a poetic act.
So we are dealing with continuous transmission through language.

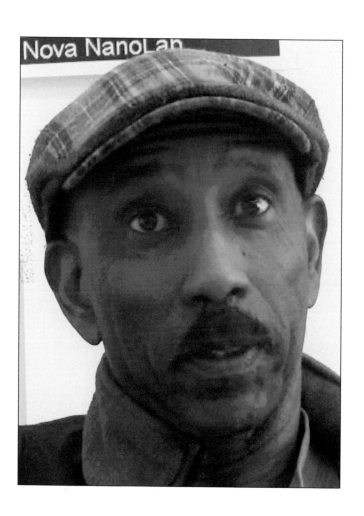

UCLA Media Arts, Los Angeles, California: May 12, 2015

Praxis

HE	**SHE**

art is I mean
you know a kind of way
of I could say well I mean
you know I never really
would say that it's
exactly you know
what I'm even saying
I mean you know
I never could really
quite understand
what it was
that so many are
trying to pursue
that we begin to
articulate in such
a clear way though with such
varying points of view
it seems hard to define
in a single sentence
or word exactly
what it is that
we are trying to
articulate and define
in a way that would
be easily understandable
or digestible by a lot of people

art is
could be anything
it could be the
nonvisible
and it could be
the visible
and you could think
that art could be
anything that is material
or anything
that you cannot see
what is inside
a person what is inside
I think I don't know
what it could be
it could be anything
that is material
or it could be
what's going on inside
or it could be
it could be anything
that is non-visible
and it could be what it is
and it could be very
very very hard
to explain

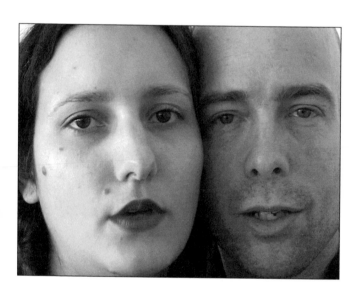

White Box Art Center, New York, New York: January 25, 2003

Robert Ashley

Except in rare instances music is obviously sound.
I feel that what I'm hearing is music when the sounds go together
in some way that the result seems crafted, intentional,
and mostly it is to make the listener feel good.
Of course that varies hugely.
But I think that's basically what music *is*.

When making it I never think of how it affects other people.
When I work I think of satisfying myself, that the parts
fit together, so that they would seem to make sense
to someone other than myself.
But I feel like I'm only responsible to myself,
and when that responsibility has been satisfied
then I think I've made music.
I tend not to have very philosophical ideas about music.
It's immediate; everybody does it.
It's somehow very deeply connected with speech.
Everybody has to talk. Music has the same origins
as the need to speak. The impulse to speak is so mysterious
but everybody has it—and so too, I guess, the need
to make music.

I've just been a practical musician my whole life.
I mean I play music. I make music.

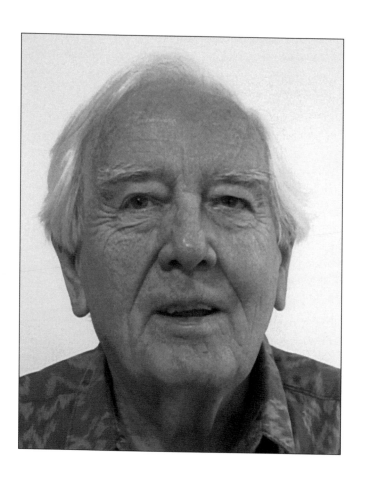

Barrytown, New York: July 23, 2008

Monika Weiss

This thing that we do, yes,
what it is!
Certainly the first thing that comes to my mind:
it is.
Despite all other opinions, it is.
It exists.
I've kind of touched it, I think.
It's light.
It's about light.
And darkness of course, too.
Being on the edge of an abyss,
of nothingness.
I guess it's
somewhere in between.

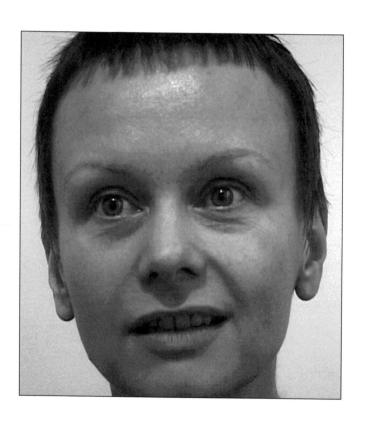

Chelsea Art Museum, New York, New York: March 23, 2003

Archie Shepp

I was seven years old and first overwhelmed by music when I heard my father play the banjo. Music always evokes in me a certain feeling of excitement. It's like sitting down at a banquet and you're not invited to eat but you force yourself to ask some-one, "Can I have a little bit of what you're eating?" I think Lester Young used to say, "Can you give me a little helping?" Soon as I hear the piano and the bass I'm energized. So music is an ambi-ance, a muse, a siren that no matter where you are when you get that feeling you've got to join in. African-American music is a very participatory event. A feeling of call and response. When the preacher says something, the congregation has to answer *Amen*. So to that degree music consumes my soul completely.

For my people, for black people, it has been very important, the folk songs, the spirituals. Music has always been a powerful element, going all the way to Africa. It's been a means of connect-ing the ritual conventions, as when a person dies in the Yoruba religion. So there's a kind of holistic relationship between the music and African and Afro-American culture in North America, South America and the Caribbean; music's an essential element in holding the culture together. In this kind of music which relies so much on improvisation and feeling, spirit is of course quite im-portant. It's been a very powerful force not only in my life but for my people and their struggle for liberation. From the beginning this music was first created by all the tribes in Africa. There's a say-ing among the West Africans that the first man was a drummer.

White Box Art Center, New York, New York: March 29, 2016

Vito Acconci

I come from a generation of artists who probably started off by having severe doubts about art. Art is the only field I can think of whose name not only describes what it is and separates it from other things, but it evaluates what it is, and I think that's the biggest problem with art—it already says it's good. Maybe that leads to all the problems with art—to a kind of self-congratulatoryness and a separateness from life. What led me to do art, from a background of writing, was a real hatred of the "do not touch" signs in a museum, because in every other field of life when you come upon something for the first time you pick it up, you turn it upside down, you touch it, you smell it, you possibly taste it, but with art the tradition is that the viewer is here and the art is there. So the condition of art is always one of just desire, and hence frustration. And it's probably a moral position, you can't touch the art because art is more expensive than people.

I think the biggest problem with art is that it's a noun and not a verb. If art were a verb it would be about the art-doing activity, which is probably as simple as something exists. Art as a noun becomes a career; if art were a verb then anybody from any other field could do it.

I don't think of myself anymore as making art. I think I'm doing architecture, design. The hope is to make people feel freer than they were before. Probably the biggest danger with all of these activities is controlling a viewer.

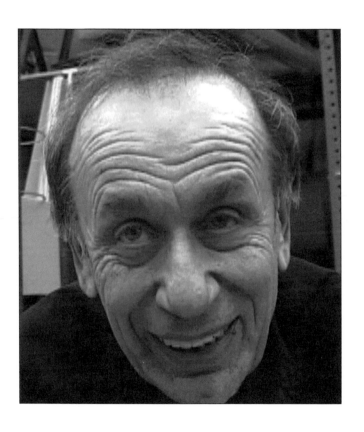

Brooklyn, New York: February 13, 2005

Cecilia Vicuña

art

de la nada
hacer de la nada

to put together

if we knew what it was
we wouldn't do it

and yet
even though we don't
know what it is

we all
know what it is

Mikhail Horowitz

Poetry is the antidote for the poison of rationality.

Poetry is exemplary prevarication.
Poetry is lies that one resists telling at one's peril.
Poetry is the goosing of dubious truths.

Poetry is the canary in the mind.

Poetry is the only remedy for the disease of speech.

Poetry is language making love to itself.
Poetry is the rhapsody of happenstance.
Poetry is an oxymoron waiting to happen.

Poetry is the sleep of reason culminating in a wet dream.

Poetry is philosophy slipping into something a
little more comfortable.

Poetry is the fondling of correspondences.

Poetry is an imaginary battleground over which
academic armies clash by night.

Poetry is illegal, immoral, fattening, possibly addictive,
occasionally antisemantic, and the last best hope of the soul.

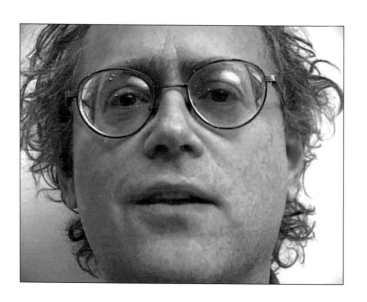

Barrytown, New York: November 14, 2002

Joan Jonas

Art began as a process of finding a way to express my thoughts
in form. So for me that is what art is: finding a form
that can exist outside of yourself,
outside in the world.
And that can be any medium.

I haven't made a radical separation between the visual arts and
poetry, literature, film; for me it's all related.
I mean, there's a difference of course, but in my work,
in my mind, I have brought it all together.

Art is altered by the medium itself.
I mean, for instance, the video camera altered one's way of
working with time. One's sense of time
is altered by the medium.

My own language is a visual language.
I find it through the actual doing and working
with materials and pictures, and maybe I use the idea
of collage. I put things together,
and that's how I find a way to express what I want to say.
But I don't know what it is until after I find it.
I think it's a mystery what art is,
you know, how one person is an artist.
I like not knowing.

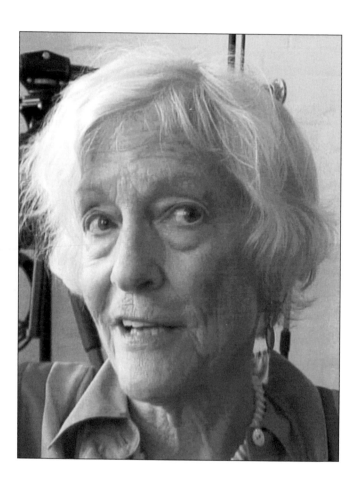

New York, New York: June 26, 2011

Konkona Sen Sharma

In a way acting is the most personal kind of art because you are only using your own body—your body, your voice is your instrument. And it's a very strange relationship you have with your own body and your own self. Because, you know, at the end of the day the cameraman can leave the camera behind and go home. And not everyone can, but the cameraman can do that, he can leave the equipment. So much of it is just machinery and technology. You can disassociate yourself from it. The whole acting thing is very confusing because I really don't know when I am just being myself, when I'm just taking on a character. There are times when I come home and I'm still kind of a little like the character I'm playing, just in terms of some characteristics, or my outlook, or the way I approach people. And I'm quite confused when we talk about it much. It's such an unconscious thing. I really don't always know what is happening and am not always in control. And that is why the director tells me, "Do you want to do another take? Do you think you could do it better?" And I go, "I don't know. I am happy to try another take but you could just keep this one. I don't know if I could do better." I don't know what's going to come in that moment. It's not like I'm trying on different kinds of handwriting. Do I really think it's very, very important to be neutral, to be completely neutral before going into a scene—no. I just think that I don't like to force things, you know. I don't like to force a situation in real life or in acting. I want to be as genuine as possible at all times.

Mumbai, India: May 2007

David Antin

art is

the name of a club

into which we try to introduce

some event or object

in order to allow it to become a family member

and if it's interesting enough to become a family member

then the name may very well stick

it's a name we give these things to allow it access

there's no characteristic that it has to have necessarily

except some affinity with some members

who are already in the club

these might be very unpopular members

they may be unusual members

they may be remarkable members

and it's probably more interesting when they are

the only problem is

that things change faster than the names

White Box Art Center, New York, New York: November 11, 2002

Camella DaEun Kim

Art is making something out of nothing. Through multiple stages of thoughts, feelings, observations; through words, phrases metaphors, images, colors, forms, shapes, equations, math, science.... You start with yourself, but you always end with other people, because there's always going to be those who look at your work. So I think it's starting as an individual activity and then ends as a collectivism—sort of a collaboration.

Art transforms, and it does something to your mind, and to your brain. I think making it involves two very different, even extreme, opposites: one's suffocating, you feel the pain; and then you can be completely spontaneous and act from your guts. I've never yet had the two happening at the same time—I would love to, but it's been one way or the other for me. The *process* of making the work adds another flavor, a texture, and contextualizes what you're creating and brings it to a different level. Can it be random? The notion of "random" seems risky in making work; it might be arbitrary but it could never be random. I think whether or not you're conscious, there's always a *thinking* process, and there are decisions that you're making; so, yes, the process, the *making* part of the work, is important. But I also think what triggers the work, what inspires you, what initiates the art making, is equally important. And then of course the end result!

UCLA Media Arts, Los Angeles, California: May 11, 2015

Alison Knowles

Art is the ultimate wilderness.

Once you find your way
over rocks
and through the woods
everything is free
and equal.

New York, New York: August 2, 2002

George Lewis

Music is the healing force of the universe. (Albert Ayler)

Music is the creation and nurturing of communities through sonic gift exchange.

Music is the sonic trace of historical and cultural memory.

Music is the intersection of lived experience and imagined time.

Barrytown, New York: July 24, 2002

Pauline Oliveros

I like to think of music as everything that's vibrating,
which is everything! The whole universe, universes, multiverse.

Music is a very moving force
and it's a very powerful force in our lives, in the world,
and nothing else moves me quite the way that music does.
I can be moved by poetry or visual art, theater, dance, but music
has a kind of power and empowerment for me nothing else has.

Anything that we do with pure intention is healing.
In a way musicians or artists, poets, dancers, are like shamans
because through their getting out of the way, allowing the energy
of what is to come through, other people are able to catch this,
and it's like opening a door other people can go through.

So there's music which comes from the voice, the hands, the feet,
which is a very human timescale.
But the universe or the multiverse has a timescale that is
almost unimaginable. I'm interested in that music
as well as the music of hands and feet and voice and instruments.
And I like to think of natural music, music of the elements,
the sounds that we hear, and in my definition that music is a
representation of perception; if I'm perceiving the natural world
as music, the representation of that is the sounds that you hear.

So that's music for me.

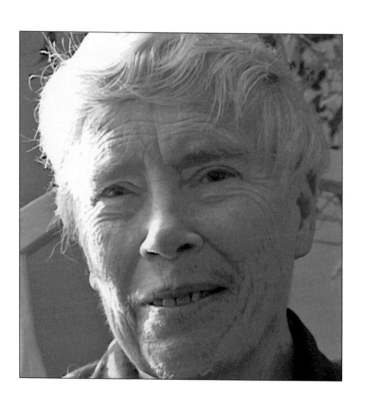

Deep Listening Institute, Kingston, New York: October 10, 2003

Thurston Moore

I think music is memory.
It's collective memory.
I think music is sort of the timeline of history for people.
It's elemental in a way.
I think it's very reflective like water.
I'm sort of a strong believer in the relationship between
human consciousness and water
and the communication to the earth.
And I think music is very involved with that
because it's all about vibration.
And so music is to me the real circuit between people
to the earth and to water and to the cosmos.
I see it as continuous memory through human consciousness,
and that's music.
And I think music people make is music,
especially sound and composition,
and improvised music and spontaneous music,
whatever you want to call it, whatever you want
to think of as music,
regardless of the academy, regardless of your own culture.
It is the great collective unconscious.

Deep Listening Space, Kingston, New York: October 14, 2003

Marina Abramović

art is

melancholic
pathetic
monstrous
danger
bloody
risky
disturbing
revolting
dramatic
communistic
sharing
interacting
meditative
secure
smelly
ridiculous
rigorous
fundamental
mystic
shiny
spiritual
aboriginal
blue red yellow green violet white black grey pink
moderate
excessive
suspicious
criminal
unnecessary
political
social
Buddhistic
hot
warm
icy
a good temperature

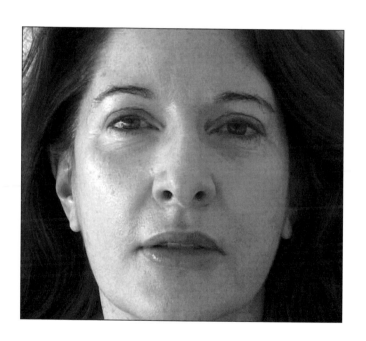

New York, New York: January 25, 2003

Caroline Bergvall

Poetic practice and artistic practice
in many ways teach me about sexuality
and the space of the body,
culturally and even in my own personal and social space.
So without art, I feel that I am not completely at liberty
to critique or even manifest
aspects of my sexuality,
aspects of my physical presence.

As a poet I consider poetry to be led not only by
linguistic or verbal concerns but also by
concerns of contextuality and situations.
Poetry for me is the possibility of creating a
linguistic/verbal environment that is in
direct contact or conflict with broader environments
that it affects
but not necessarily verbally.

White Box Art Center, New York, New York: November 9, 2002

Gary Hill

art now
right now
right behind now

art is

art is beauty

undeniably
beauty

breathtaking

disturbing

art needs to happen
art is happening
art is being

art *art*

Seattle, Washington: April 24, 2003

Eleanor Antin

I think I know what *artists* are.
Well, I know what artists *do*.
I don't know if it's a "necessary" part of your life,
but it's my life.
That's what I do.
Necessary is the wrong word.
That's what I do.
I wouldn't recognize myself if I didn't.

New York, New York: September 23, 2003

Lawrence Ferlinghetti

Poetry

is the voice

of the fourth

person

singular.

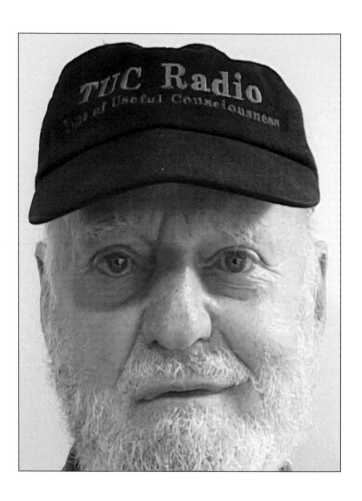

Barrytown, New York: August 28, 2002

Joy Mboya

A difficult question. So what is art after all?
There are many different layers to life.
And I think one layer is the layer where we think rationally
and we try to make logical sense of life around us,
and to be creative in that logical way.
I think art is the part where you really cannot find
the boundaries or the definitions.
But it's still a way of trying to understand ourselves,
trying to express ourselves, trying to *be*.
So I guess art is about being a human being.
Art is about being alive.
But it's being alive in the places where
sometimes words are not enough.
Maybe that's why we write songs, or maybe that's why we paint,
or maybe that's why we dance.
So, it's trying to find expression beyond things that are obvious.
I think that's art. Or one of the ways in which one can define art.

So who am I?
Who is Joy the human being?
I think art is one of the things that allows me to understand that
or to find that or to explore that.
So yes I think it connects.
So it connects me to myself
and from that connection begins to
connect me to my environment.

Nairobi, Kenya: February, 2007

Robert Kelly

I think poetry is letting things speak through you.
Letting the earth speak.
Not giving the earth a voice—the earth has many voices—
but giving the earth words.
I've been thinking a lot about this lately; I want poetry to include
all verbal art of any kind, written or oral, prose or poetry,
because I think to make our silly little genre distinctions
into ontological categories is a real blunder.
It might be a nice academic convenience,
but it is a spiritual blunder.
I think then that poetry is letting the earth speak.
I think everybody notices that they write one way in one place
and another way in another place.
And it is so obvious a thing that I suppose, like most
obvious things, one doesn't notice it.

So I think poetry is just listening.
Poetry is listening hard.
The more attentive we are to listening the less likely we are
to be paying attention to our own wishes.
So I think what poetry *isn't* is self-expression—
except in the sense that *expression* means to *squeeze out*, literally.
If poetry is what's left when the self has been squeezed out,
that's a nice goal for poetry.

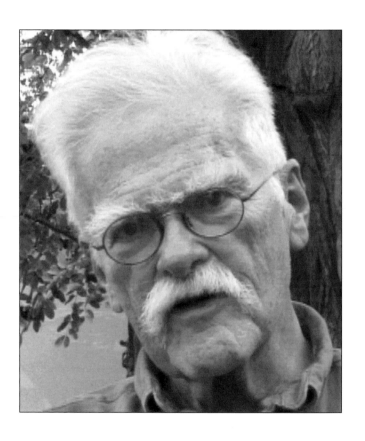

Barrytown, New York: August 26, 2009

Victoria Vesna

The moment you define art that's not what it is anymore.
So anything I say is not going to be true the moment I utter it.
But to define it in the sense of what I do that others call art:
I work with our current social and human dynamic and
I'm a filter. I get bombarded with information like everybody
but I try to work on it thematically and aesthetically so that
I give another angle to what we are experiencing collectively.
And try to receive back from the audience the response that
makes it all be a co-creative process. Maybe in some sense it
prepares others to what we are going to witness.
It can access the unknown, mysteries we can't even define.
Art is transformative.

In Bali there's no word for art. That's the way it should be.
But because we are so alienated from the spirit and from
true values we have had to relegate art to a separate dimension.

Recently I have witnessed a lot more art creativity in science labs.
It's not necessarily related to what is *called* art, which is visual,
but to me it's art. My interest now is to show how technology
is part of our human condition and can be used to accelerate
and amplify the creative process, which is evolving us as a race,
and to show how science is also culture, how artists and scientists
can work together to connect to the spiritual.
Creativity between art, science and technology, and the spiritual
is the contemporary condition where "art" would reside.

Barrytown, New York: July 2, 2005

Jonah Bokaer

I make dances with my life. You could say *live to dance* or *dance to live*. But making dances is a very, very ephemeral act. And by the time it's shared with an audience it's usually at the end of a long process. The art is somewhere between the conception of the work and the public delivery of the work—and I'm very interested in that inbetween space. And I think that's where the art is, in the act of creation.

Duchamp talked about the audience completing the work. I'm such an admirer of that statement and that contribution to how we think about a work. Especially in the case of dance and performance, the public completes the work. For me the act of making it tends to involve staging, teaching, and creating on dancers, on other bodies. So there's ideation or conception, then staging, and then the performance.

Dance is an art of people moving, often without text; so the non-verbal, visual, yet human physical form of communication is primary. Yet there will always be within it another mode of communication that's beyond just the body. The structure of dance can eventually arrive at a kind of linguistics, depending on the artist or author: in a way, movement is the text and dancers are the pages. The movement gets imprinted on the dancers.

Dance can have a transformational impact on the viewer, not only in terms of appreciation; it can make you see and feel and become moved in a different kind of a way.

Barrytown, New York: February 14, 2016

Adeena Karasick

Poetry's process approaches language and meaning production
and the ways that we interact with language to create
alternate realities of being.
Think about how language creates being—the world
is created, Kabbalistically, through the potential of 22 letters
which breathe life into all things.
And through every articulation we're re-creating,
continually reforming ourselves, our being.
This play, this heteroglossic enunciative process
where all meaning inscribed can be multiply resonant
through the body, through the dictionary definitions,
the intertextual references, the palimpsestic layerings of
history, culture, identity, subjectivity, all reshaping the world.

Two different mediums: writing and performing—
two beautiful realities, neither a transcription of the other—
how you can engage so intensely and passionately
and create so many possibilities—the letters are vessels of
light, chariots you are traveling through to further meaning.

There is nothing more beautiful than being on stage where
you are so inside what you are doing and the audience is feeling it
and they are transformed as much as the performer is.
The intensities of sounds & energies & histories & knowing
converge in the room for that time, and then when one leaves
one is never the same.

Barrytown, New York: December 19, 2015

Eva Karczag

I was thinking it's the
translation or
the transformation
of life experience and
visionary experience.
The transformation and embodiment and communication.

And then, I think because I'm an onion peeler, and
I like to get to the heart of things, or the essence of things,
I thought, well, that's too much.
And then I just got down to, well,
art *is*.
And then this morning as I was working I was thinking,
well, maybe that's too much too.
And actually, really,
there aren't any words.

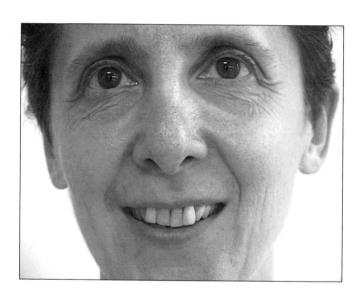

New York, New York: August 2, 2002

Michael Meade

The origin of "poetry" is, in Greek, *poiesis*—to make, to create.
So poetry, the way I've learned it, is the natural speaking of the soul.
Philosophy, for instance, used to be written in poetry,
up until a few hundred years ago.
So that thinking was a poetic act, an act of creative language.
And then there's that wonderful idea that someone said, poetry isn't
heightened speech, it's the *natural* speech of the soul,
and everyday speech is the collapsing of speech
with the spirit falling out of it.

The struggle right now, I think, is for language in the real sense,
for creative language.
And we see it off course, the incredibly diminished
language of bureaucracy,
including of course the president [George W. Bush]
being language deficient,
amongst his many other deficiencies.
So you have the standardized testing of children
as if people wanted to standardize their children.
I've never met a parent who did,
but along with leaders who can't talk
it collapses from statesmanship
down into gutter politics.

Archibald MacLeish said that a culture dies
when its metaphors die.

Mythic Journeys Conference, Atlanta, Georgia: June 4, 2004

Ione

My first thought is that art *is*,
which possibly has been thought before,
that it is something that exists
and is irrepressible and there's no stopping it
and it's all around us.

I'm very interested in art as multiplicity
or the ubiquitous aspect of art
rather than the narrow understandings and definitions of art.
I'm more interested in what happens from our
deepest creative places
such as indigenous societies' creations of their works
which later get hung in art museums and are called art;
but they don't call them art.
They just *are*.
They are an expression of their essence
in the world.

So I see that art
is.

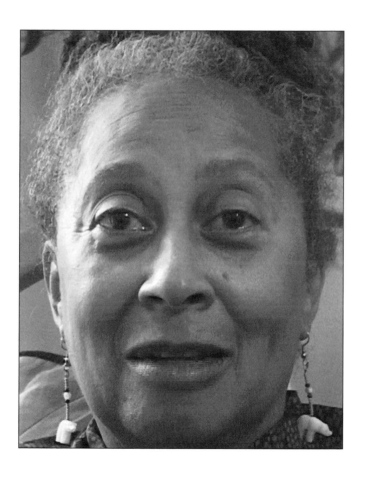

Deep Listening Institute, Kingston, New York: October 20, 2003

Peter Lamborn Wilson

Poetry is more like action than prose.
It's like in elementary school when you used to do show and tell.
To me prose is like telling but poetry is like showing.
So it's more like action. But it still isn't itself completely action.
It's still writing and therefore it still must be representation.
And for that reason I've pushed what I do farther
towards the pole of activity, action—
I guess leaving behind the simple written page.
I do these vanishing art installations or routines or works,
or I *have* been doing them, as prolongations of poetry
into a further level of action.
It seemed to me that I would go back to poetry
knowing full well that it's a failure.
That it doesn't communicate. That it's not taken seriously.
And that I would just have to live with that.
I would have to write out of that. Write in that position.
Because if you try to think seriously of poets—
poets as unacknowledged legislators—
it may have been true once, but in the post-modern period
it no longer seems to be so.

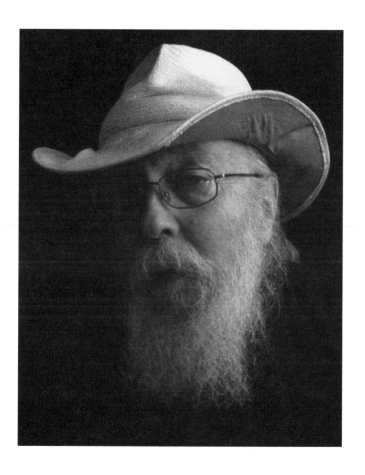

Barrytown, New York: October 2, 2011

Carolee Schneemann

There's a Duchampian and physiological suspension of placement
that's always being questioned in my childhood drawings.

Where is the body between?
Where is the weight between?

The painting then leads me back into
this physiological engagement
where the body has to follow the perceptual.
And the perception and the muscularity of
the eye to hand.

So the body's always active.

Bard College, Annandale-on-Hudson, New York: March 17, 2003

Shuddhabrata Sengupta
(Raqs Media Collective)

Raqs is a word in Persian, Arabic, Urdu, and Hindustani, the language of the city in which we live, Delhi, which connotes movement, kinesis of different kinds. It can simply mean dance, so *Raqs* is a dance, but also the sense of ecstasy, for instance, that whirling dervishes enter into when they whirl; we saw a whirling dervish in Turkey once and realized that's exactly what it is. So it has that *axial* notion of rotation around a stable axis, and the whirling dervish figure has one antenna pointing towards the heavens and another pointing towards the earth. So it's like a lightning conductor in some ways which channels energy. We have always thought of it as a form of kinetic contemplation—instead of a mode of being still, ours is committed to being more in the world, being in movement, on the planet we are on; we are on a wandering planet; it moves; we move on it; it rotates; it orbits. One can experience the universe, history, this moment, as a series of ways of understanding movement. RAQs is also a sort of jokey acronym for the expression *Rarely Asked Questions*, as opposed to FAQs, Frequently Asked Questions; so our art is the rarely asked kind of questions.

Surjection—a show we did in Toronto—means you try to create relationships between objects based on a conceptual understanding of what they are, yet know they belong to different entities. Being a collective is a bit like that—we're the same kind of "objects," but actually different bodies—as in the idea of *dependent origination*. We are what we are in relation to the universe. So '*sur*' isn't about being *above* anything but thinking of being as *immanent entanglement*.

94

Barrytown, New York: December 15, 2015

Laetitia Sonami

It is an experience or it is actually the gap
between oneself and a possible experience.
So you spend your time trying to achieve that possible experience.
But you don't know what it is.
So, I think a lot is maybe staging yourself
so that you maybe have some kind of
possibility for that experience to occur.
I think if you know it then it is not anymore an experience.
It's already gone.
I think a lot of what we do is an effort
towards that place you know,
trying to reflect that place.
Most of it seems to be effort with some glimpses.
But, you know, it's always moving, it's always changing with you,
so it's very hard, because you are always walking towards that gap.
I mean, you're always fulfilling, filling that gap,
and then the understanding changes.
And then it's like a whole horizon always seems to arise,
so you are always kind of seeing what things could be like,
and trying to realize them,
and then as you think you realize them,
usually it's not really true, in a way.
This kind of constant curiosity drives it.

Nothing is to be gained by saying what it is, I think.
I mean you hope that people get a feeling for what you do,
but you can't really say what it is.

Barrytown, New York: July 9, 2004

Chris Mann

I think it's the confusion
between the issue
and its response.

I don't think it's anything else.

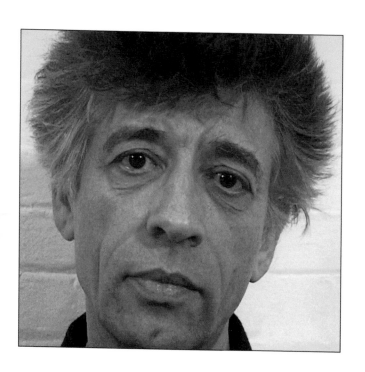

New York, New York: March 2, 2003

Yayoi Kusama

What is art?
Art is art.
I don't know what is art yet.
Maybe I'll find out what is art.
I am not an artist yet, you know.
I am working hard to make art.

Art is everything.

New York, New York: December 9, 2002

Evan Calder Williams

Even if I worked solely as an artist I probably would still think of art as a constellation of different activities. What I do is already scattered: I work as a theorist, writer, researcher, and teacher, and then there are my activities that fall slightly more under the guise of art, like film and performance. But the arcing category of pretty much everything I do is the essay, in a quite expanded sense. There's a fundamental incompleteness to the essay—Montaigne talks about it in terms of grotesque fragments that he assembles. And work that gets called art can be a place to take the constitutively unfinished element of other activities and let them hang open in different ways—to not feel the need to bracket them off or close them. So art remains compelling and necessary. Despite being generically within the sway of markets and commodities, it still matters to me as a discrete activity that can range through the incomplete edges of our activities and histories.

For me, it's also a form of letting ourselves be taken over by those fragments, those histories, their effects. There's a long tradition of thinking this way, like the figure of the daemon or the artist as transmission mechanism, which I think is still true in a way. But we also actively pursue linkages we suddenly feel between these strands and pieces. It's not full-on automatic writing, but even if I'm making images, there's a central syntax, a connective tissue or relation of difference to be found, rather than made. It feels like things suggest themselves to us as deep links we were not remotely aware of. And it leads to a trusting and intuitive state of mind, picking up on traces or articulating problems—we can pretend that we just had the idea, but perhaps it's been having us for a while.

Barrytown, New York: March 21, 2016

Iva Bittová

If you develop in music, practicing and knowing
every detail that comes from body and mind
and joining with the instrument, violin or voice,
it brings an amazing, huge space of freedom.
It's like the air, you know, it's like breathing.

You have to choose what resonates with you—
which also helps you to be healthy.
And for me music now is like healing.
I conduct workshops for all ages of students,
and I see the faces, how they open their eyes
and feel happy and open. It's therapeutic.
Sometimes music helps you get back to your childhood,
bringing back a kind of energy that children have,
to be open, to have open fantasy.

It's beautiful to improvise and get big surprises.
Sometimes on stage I hear something that came in a dream.
Music gets printed here in the mind.
And when the music comes back I can take it further.

Music can change not only people but the space itself.
I feel that it affects the other side of the planet.
We are not just right here.
Music helps me connect with energy from very far away.

Barrytown, New York: February 26, 2016

Clark Coolidge

It's a language.

It's funny when you're talking about poetry—
of course it's a language.
But poetry is a different language than English.
If you're an English speaker, it's a way of speaking of things
that you can't speak of otherwise.
That's why I'm impatient with poems that are about
trees and love affairs. You can talk about that,
and you can kind of communicate it.
But poems can speak of things that are otherwise unspeakable.
And that's the great crux of the problem.
Sometimes that breaks out in a beautiful shine
and sometimes you are endlessly frustrated … but
as I get older I feel less able to give you a definition of it.
I'm sort of wonderfully puzzled by it more and more.
And that's wonderful because it opens up vistas,
things that you don't know about,
things that you can't express—
terrific, you know.

New York, New York: March 9, 2011

Nilufer Ovalioglu

Frankly I find the question a little bit silly.
Can I say that?
Because throughout my whole education
I have been educated to be an artist
and there were a lot of descriptions and formulas
to describe to me
how I should do things
and why I shouldn't do things,
but I wouldn't be in so much pain trying to put things together
if I knew what art was.
And if it was in a formula
I would be such a perfectly happy artist.
So, I guess I don't know.

I couldn't survive in any other way.
I mean, okay, I can be a waitress in my life,
I can be a lawyer,
I can be anything,
but I realize that
I cannot live one day
without writing down an idea
or drawing something
or putting things together,
or editing video.

Jonas Mekas

I used to know what poetry is.
But I have forgotten.
Now I don't know.
The only thing I can say is that poetry is
the sum total of what poets do.
So that poetry is what poets do.
It's like a farmer doing his work. Agriculture.
But poetry is what *poets* do.

It's like doing a pirouette.
Maybe that's dance.

Brooklyn, New York: May 28, 2015

Pamela Z

Music is to art what painting is to art. It's *an* art. So it's part of what art is. When you're growing up people talk about music and art as separate things, because an artist is to them someone with a paintbrush in their hand. There are many different disciplines you can work in that are art.

When I played music from an avant-garde composer, people would ask: how can you call that music? And I'd say, I think that the maker of it makes it music. Whether or not it's music that speaks to me is a completely different thing. Music itself has such a weighty history behind it. There are types of music that are much more or much less musicy musics. But for me it's kind of the Cageian thought that organized sound is music. And it can be organized by the person who is creating the sound or it can be organized by the listener who in their own mind organizes it as being music. When you're playing *4:33*, you actually aren't making the sound. You're making the existing sound into music by the act of the way you are listening to it. Music is definitely about sound. Is all sound music? Is all Sound Art music? Some people say no, and I feel like a lot of the people who don't want to call Sound Art music, are sound artists themselves, who don't like music. And they never wanted to be a musician; they just wanted to work with sound.

For artists, art is a process. And for other people it's something to regard, it's something finished that they can look at.

Barrytown, New York: July 7, 2004

Ulay

The core of my art is a good feeling. And I never came across anything that was better than good feeling. Even the hard stuff, all the extreme stuff—it always remains a good feeling because you do it for others. But you cannot stabilize good feeling.

"Art" is a word. So you know, it's an interpretation or reinterpretation or misinterpretation; it's a *word*, so it's an intellectual exercise. The *core* of it is *not* an intellectual exercise. I'm an artist even when I sleep, and that doesn't need a definition. That doesn't mean that I don't know what art is. I'm afraid I could not in an intellectual abstract way add the missing words. It's all about interpretation, and I guess many artists say "I don't know." I *do* know what art is, and it doesn't need a word. If I provided a word, maybe I'd stop doing art. As long as I don't provide that one missing word, I keep revealing, keep on revealing, revealing…. But with changes, different approaches, different targets. And, you know, for the longest time what I did was very ego-based, ego-centered; it had to be, because otherwise I couldn't have done what I did. I'm not an artist who's comfortable in working by myself, in solitude. I have always exclusively worked in a social context. This is much more comfortable. And to get it together takes a lot of ego stamina. Because it was a lot about endurance; there was a lot of physicality involved; it was a lot about finding your limits, your limitations. So we needed to be very ego-stamina-centered. But now it's different. Now I turn it to a different value.

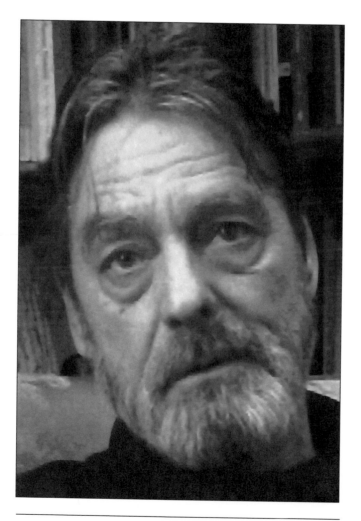

New York, New York: February 25, 2007

Laurie Anderson

Whenever anyone asks me to say what it is, I avoid answering,
because nobody really knows what it is, and I certainly don't.
Its definition shifts every time somebody makes something
and calls it art.

I think it's very possible that in the future people won't actually
be making art objects. I think more likely we will be enhancing
our own experience. In other words, imagine if you could hear
a hundred times better than you do now. Or you'd be able to
zoom with your eyes. You could always be making and
experiencing the world in ways that are more intense.

If I had to answer, I would say making art is paying attention.
That's it. But I just don't have the urge to define things.
People who enjoy doing that I'm all for it, but I prefer
to make things as undefined as I can, and that helps me to
not feel that there are any rules. Because, there really aren't any.
My favorite art has internal structure.
My favorite art breaks rules, then makes its own new set of rules.
But that's just what I particularly appreciate,
and it's not in any way a definition.

People make art for various reasons: to put it on the marketplace
and treat it as money, which makes it look a certain way; or
having to do with their religious beliefs…. I make it for fun.

New York, New York: December 9, 2007

Robert Wilson

The reason I work as an artist is to ask questions, and if you know what it is that you're doing then don't do it. The reason you work is to say, *what is it?*

So that's a basic premise as a foundation from where I work. I don't see much difference between designing a chair, making a film, or video portrait which I'm doing now, or making a play, or designing this building that we're in—it's all a part of one concern. Marcel Breuer said, "In this chair I designed are all my aesthetics."

The same aesthetics that go into designing a building, the same aesthetics that go into designing a city, are inherent in the detail of the chair. We look at the Shakers, we look at the Bauhaus, we'd see a man who would be a photographer design a carpet or curtain or textile, teacup, a table, a chair, or a building or a city, it was all part of one concern. One of the few things that remains throughout history—we go back to the Egyptians, we go back to the Chinese, the Mayans, we go back to any culture— one of the things we look at is what artists have done. So they are the records and the journals and diaries of our time. The artists today are recording our times. Five thousand years from now no one will think about the war in Iraq, but they might think about what the artists have contributed. My work is very personal and it wouldn't be what you would do, or what someone else would do, but it's certainly been influenced by looking at the history of art. We understand society by the nature of the individual, and we understand the nature of the individual through the history of art.

Water Mill Center, Long Island, New York: August 4, 2005

Silvia Nakkach

Music is a mountain.
Music is the space in between the notes.
Music is the sensuality of tone meeting tone.
Tone indulges in sound.
It's a slow process of encounter.
And it's meeting. It's a meeting, it's an encounter.
Music is an encounter that is infinite.

Music is like the ocean.
It has all the moods and wraths of the ocean.
It could be very brave,
it could be very scary,
it could be open,
it could be very tight.
Music can be an experience of Romanticism
or music can be an experience of aggressive pain and sorrow,
but it's beauty.
It's the beauty of being compromised
with beauty.

Conway, Massachusetts: September 15, 2006

Jerome Rothenberg

Poetry is best if it's left undefined or indefinable.

To go into whatever arenas it goes into.

But it's seemed to me, over the years, there are
personal definitions of poetry—ego-centered definitions—
"I need this, I want this, I like this," you know, "I revel in it."

And for me *personally*, as someone said to me the other day,
poetry has been good to me.

So I wanted at a certain point to treat it as the center of my life,
you know, or as one of maybe multiple centers,
and having done that, at least for the moment, I can look back
and not regret having made that decision.

In that way poetry for me is also part of the definition
of a life worth living.

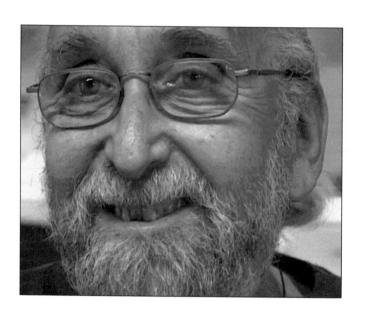

New York, New York: October 3, 2002

Rochelle Owens

Kwame Anthony Appiah said that one should accept
multiple identities that one has, without privileging one
over the other if one doesn't want to.
Language and poetry contain a rhythmic dynamic,
whether I know it or not or even try to escape it.
I remember before I was aware that I wanted to be a poet
I was around eleven or twelve in a ballet class
and the ballet teacher was looking at the students
and a line came into my head; it said:

come hither come hither come hither jump jump

So, I would say that it is a journey with disruptions and
chance—phonetic … imagery … pleasure.
If I'm writing something that I know is not going well,
I intuit and know that it's not going well.
And then when something is going well it's a visceral feeling,
it really is, my skin and my joy appreciate the process.

David Behrman

You could say music is vibration of air molecules.
But that's only part of the story.
It's also the computation in the brain after it receives the signal,
and it's also the objects like violins and compact disks and gongs,
and it's also the sounds of the trees and birds.

It must be what each generation of musicians tries to figure out.
Maybe what music is is too big a question
because it's a universe, really,
and intersects with other universes.
And it seems that artists, musicians, are looking for where they fit,
which is going to be a small corner of the universe.
You can define music in many different ways
but it doesn't seem interesting to define it narrowly.
Sometimes bad things can happen to music.
The commodification of music is a bad thing of course
and that is part of the capitalist world that we are living in.
On the other hand, it has magic powers
which transcend those commodifications.
Sometimes magic things happen when you are doing music,
but you're lucky if something wonderful happens,
and it's rather rare in my experience, it is rather rare
to have that wonderful euphoric feeling that artists sometimes have.
There are very lucky days.

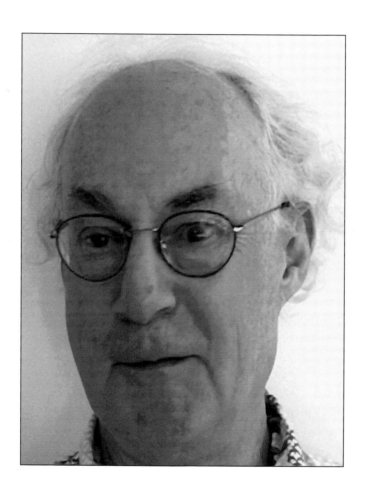

Barrytown, New York: July 9, 2004

Laura Ingram Semilian

Music is meeting something that's shaking out there already.
The tone's already out there and then you just allow yourself
to meet it with your body.
And then comes the technique—I mean of course
you *learn*, you get a toolbox, that's what training is.

Sound sculpture.
The sounds tend to *visualize*; the notes or the chords correspond,
they have a color or a texture connected with the other senses.
And they're also components of a larger picture.
I mean I appreciate the idea of music for it's own sake,
but for me it's always part of a puzzle, part of a larger expression.
It manifests, say, historical time, a feeling state, an experience.

I visualize the sound waves going out—how some animals
find their way around—echolocation.
Mapping your environment by what you get back.
You only know the topography if you send out the signal.

It's in the waiting. Tension is important, and timing.
Not being afraid of it—that seemingly blank space is *pregnant*.
Waiting for the wave, knowing the right time to hop on.
It's not work if you pick the right wave at the right time!

Barrytown, New York: August 4, 2015

Charles Stein

It seems to rise on a certain current of psychic impulse
that I recognize is there.
That would be one aspect of it.
And it's what Robert Duncan called a certain body tone,
and I recognize that as one of the aspects of it.
Another really has to do with something you might call thinking,
although it isn't thinking in a completely discursive or
abstract sense, it's thinking at the edge
of an intuition about things.
And soliciting some kind of utterance to say
what it is I'm trying to get to.
And an awful lot of my poetry writing comes out of
just that impulse,
where I'm on the edge of having a sense of something.
And just go for it
and see what kind of language it falls into.

Barrytown, New York: February 20, 2003

Heide Hatry

Normally I would say that intention and result are important, and the result has to touch your heart. The result is more important than the concept. For me the artwork needs to be aesthetic and has to kind of jump on my shoulder and grab me and do something to me. I need the body feeling, the emotion, my breath to be taken away. Making it is almost always completely unconscious.

The first artwork where I used skin material, meat which I got from the slaughterhouse, brought a kind of catharsis, and working with it I thought this real, fresh material is amazing, and you can do things you cannot do with anything else. For example, make a big sculpture which looks like a kind of abstract female body: sew it together, fill it with stones, put it somewhere in the landscape, and then let it rot. Take photos of this half corpse-like thing—obviously a human female body, but not a real body. Finding this material basically treated as useless, thrown away in a slaughterhouse, I tried to make realistic faces, bodies, parts of human beings. I was never so interested in the artwork as a product I could sell, because it's ephemeral, but pieces of animal skin resembling a human abstract body in a landscape, that became an artwork for me. Just a photo of the rotten body touched me so much, not that *I* made it, but the thing itself. I don't know why. And I think this not knowing why something touches you so much is what fascinates me about art—why it makes you feel so different, or so happy, or so unhappy.

New York, New York: March 18, 2016

Charles Bernstein

Poetry is the actual words on the actual page.
But the problem is, there are no actual words
and there are only imaginary pages.
This poses serious problems for both materialists and idealists.

Poetry is like coffee.
It keeps you up.
At the same time, if you drink it too much,
you tend to fall asleep.

In dreams begins a lot of bad poetry.
But that doesn't mean that poetry is not connected to dreams
but that the way we remember dreams is often less interesting
than dreaming.

Poetry is a metaphor for that which has no likeness.

Poetry is being possessed by the soul of words
that are not yours
and making them somebody else's.

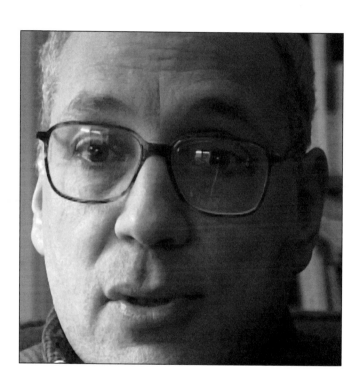

New York, New York: December 10, 2002

Monica Narula
(Raqs Media Collective)

The fact of sitting on a toilet in Delhi and watching this little stain that appears on the wall. And everyday when you sit there you see it growing bigger and bigger and it was hardly there to start with. And then it gets bigger and moldier and little bits of paint start flaking off from the wall and then you start thinking about what is to be done about this. What is to be done with this stain? With this mold? With this disfiguration that is happening. Should you get it painted over? Is it the monsoon rain that has clogged up? Is it the pipes? What is wrong? Should I break it down? Should I do it again? The fact of a structure put under pressure because of a kind of invisible capillary movement of lots of things at work which causes anxiety at some level for those who are invested in the structure, including me in my bathroom, but the fact is, if you stare at those stains long enough you begin to see patterns, you begin to see faces in the mold, and you can spend a long time staring, and seeing people you recognize or landscapes you might wish to go to, and also you do realize that it is this stain, this ugliness as it were, which is ugly if you look at it from one perspective, but it's also going to cause change in the way the building is. And for me, both of these things are art. Or what can be art, or what artistic practice can aspire to be. One is the ability to stare at the stain and to see patterns within that, to see the landscapes and the faces, and to keep looking until you see something more. And on the other hand it's also practice that causes anxiety, forces people to reimagine what structures can be and what encounters can be.

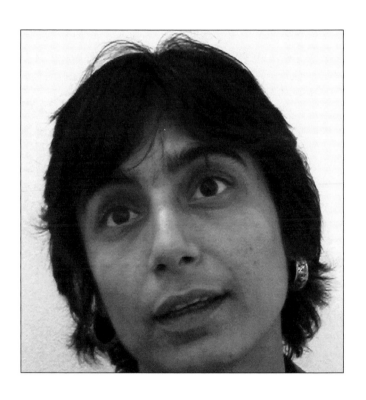

WRO International Media Art Biennale, Wrocław, Poland: May 4, 2003

John Beaulieu

Music is organized sound. What *isn't* music is a more interesting question. If you take away the organization then you have sound. And sound by itself, without the mind imposing music on it, becomes rather interesting. It's our perception of sound that creates music. We can focus in a way *un*organizing our perception in order to actually perceive sound without music.

Music that's attuned with the human body and structure, how our form is organized, is naturally attuned to a mathematical equation called the Golden Mean which sets up an infinite spiral, allowing us to enter into it with our physical body and resonate with it. At the center of the spiral there is no-thingness, or what the alchemists called the Eye of God or the Philosopher's Stone. When we resonate with the actual form of the spiral—that is, with the way the body actually develops and grows—we can gain health, wellness and the ability to transition in and out of many different states of consciousness, effortlessly and naturally. Scientifically we know that this resonance can spike certain molecules, such as nitric oxide that's fundamental to all health. Some states of consciousness spike molecules similar to marijuana, tryptamine molecules like psilocybin, ayahuasca, and LSD, based strictly on listening to sounds. This is sound outside the context of music, like the sounds yogis, the rishis, sitting in caves heard at the edge of consciousness and called *bijas* or seed sounds—something quite beautiful like the "music of life."

I've thought of myself from earlier on in my life as a composer; now maybe I'm a decomposer.

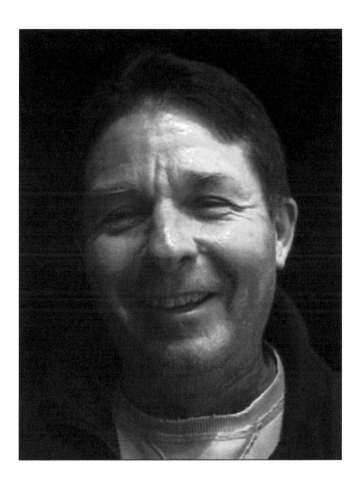

Barrytown, New York: February 22, 2009

Judith Malina

Poetry is a form of using language to convey
what we want to understand,
but hardly understand yet.

Poetry is a way of catching the sparks as they fly
to enlighten the moment
and serve as real light.

Poetry is a way of using words as a mystery.

Uptown Café, Kingston, New York: December 17, 2003

David Arner

Music is—That's already a complete thought.

Music is what you hear. That's really what it is.
So it doesn't have to be anything that somebody composed.
But it always has to be something recognized that that is music.

The whole idea of composing music is something else.
I don't think of it as music—that's a creative process.
I think of it as an art form. The creation of something.
But music is bringing forth vibrations that are already insinuated
in the ongoing creation of the universe.
It's just a matter of bringing that forth.
I have an instrument, piano; so that's how I do it
but it could be any way at all.

It's not about expressing something. That's what it's not.
It's about opening yourself up to the moment.
The instrument—it's a good name for what a piano is—
is the means of making something. You make music.
But the music is in the listening. That's where it is,
so I make music inasmuch as I'm listening to what I'm doing.

Music needs to have sound. But the idea is that you are
just bringing forth that which is, being open to it.

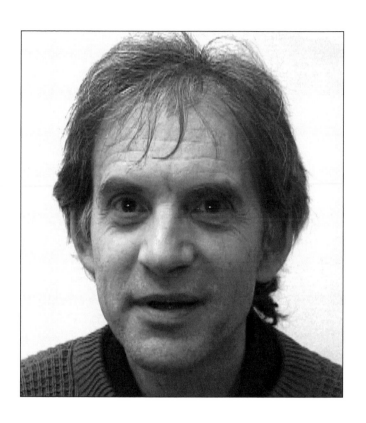

Barrytown, New York: February 26, 2003

Richard Teitelbaum

Music is perhaps the art that can touch people most directly and most strongly. It seems it can move anybody. You don't have to be a specialist or even study the language.

Music has been many different things for me at different times. In the past I was more interested in the experimental aspects, doing things that were new and different, playing the Moog synthesizer in the 60s, using brainwaves, technological advances, and interactive computer music. And another aspect of music has been mixing of different cultures and trying to experiment with that approach. And I'm still doing all that, but now I am much more interested in being very direct in my music and in frankly trying to touch people's hearts, to move people in a direction— idealistically, perhaps too idealistically—that hopefully will have some bearing on what I perceive to be the current crisis in the world, which seems to me to be more severe and acute than it has been for many years. And so I am trying to make music that will move people both to a higher spiritual understanding of this crisis and if possible to some sort of political or social action.

I was thinking earlier of Shakespeare's "If music be the food of love, play on!"

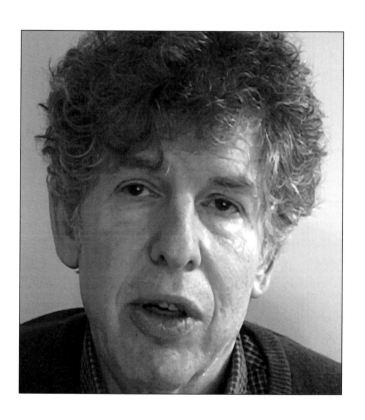

Barrytown, New York: October 16, 2003

Carla Harryman

Something I can't quite put together
is that I often think about art practice in terms of the skeleton.
It's the skeleton of the body and
the way one might think about even moving one's jaw as skeletal.
But also the skeleton in the closet
which then becomes something that has this potential for
an endless amount of possible costumes that you might put on.
And that word, the skeleton, connects for me with some way
that I think about art itself or art practice itself.
But when it gets to how I actually look at any given thing
or think about any given work of art
or think about what I'm doing,
I'm not sure exactly where that comes in,
so there might be some kind of physical experience
that's very pleasurable
and that I associate with that word,
that is related to something that actually isn't identical to it at all.
So I don't think of it as some kind of
encompassing metaphor,
or anything like that.

White Box Art Center, New York, New York: November 9, 2002

Benjamin Boretz

Some of my ideas about collective soundmaking come from watching dancers at work. What dancers do when what they're doing is just pure movement (as warming up for practice or performance) is frequently much more expressively interesting and engaging than what they do as official "dance"—Meredith Monk has obviously caught on to this with her half-callisthenic/half-worklike ensemble inventions. Invidious generalizations aside, a lot of high-art dance is constrained creatively by its repertoire of conventional stylistic riffs. Like routine jazz or other performative improvisation—but of course that doesn't describe the great inventors—either of a Thelonious Monk, Merce Cunningham, John Coltrane ... —but it does recognize that there are possible or even existent media for people who are not John Coltrane to function expressively in ways that are very interesting as pure expressive soundmaking, though not necessarily as "composition." And I guess that's one reason why when I do real-time sessions I don't like to call them "improvisations"; I think of them as open to any contextual outcome, designable or not. Had our practice merely demonstrated that we could extemporize a mediocre simulacrum of what we could do far better with premeditation that wouldn't get us any place we would be interested in going.

So it's important to me that we don't know in advance what kind of events we're going to experience—what kind of music it will be, or even if it will be music at all. And as I once said to the Bard College MFA community, "if you know what you're doing, do you have to know what it's called?"

Barrytown, New York: October 21, 2003

Christopher Funkhouser

To me poetry is not just about writing.
Actually it's about the way you live and receive the world.
It isn't one thing—it can't be for me.
I've tried to remain open, even as I moved off into the
digital sphere, digital production, multimedia work.
I can still see that as poetry. Not everybody does.
But to me it's an open system, and it's complex.
What ties these things together for me, the way I can
justify or rationalize them, is lyricism.
Language has an innate lyrical property.
So even if I'm writing out of algorithms
I am paying attention to how it sounds when I read it,
or how I hear it in my head.
You can sing Wordsworth, and you can sing Jackson Mac Low
if you try hard enough—maybe not all of Mac Low, but a lot.
In my own compositional process the lyrical value is a part of it.
It's a personal form of expression but it's not *intimate* personal;
it's something else. But it's not one thing or another;
it's something and something and something else,
and to someone else it's another combination things.

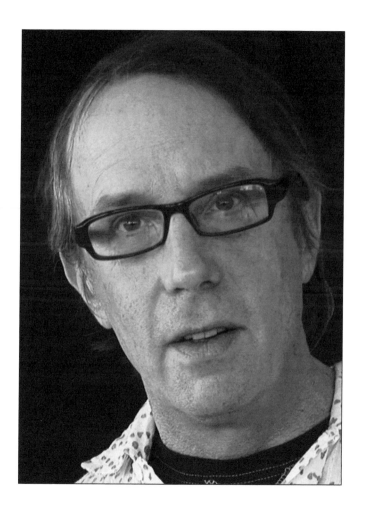

Barrytown, New York: April 2, 2015

Steve Kurtz

Art to me is a cultural construct that binds together processes, materials, demographics, and power formations. It makes them legible and creates a kind of specialized discourse and specialized production that is one vector in overall cultural production. One of the reasons that I'm not a specialist in art is that the artificial boundary that's made by the construct is in some way against what you would think art practice would be. Whether you see it as creativity or combination or invention, that boundary is bothersome. Happily during this period I'm making work the boundaries have been perforated, and we understand the idea of intersection, that specialization may not be the only way to manage knowledge. So that's the condition that allows me to do the work that I do. Some people tell me the work I do is not art, and I think that's because they are coming from a very specialized point of view. When you get to very experimental phases of art, it defies specialized definition. That's one of the reasons in our work we never announce what we're doing, whatever it is, or that we're artists; we just do it and let people put it in whatever frame they're comfortable with, and we'll discuss it at that level.

The Graduate Center (CUNY), New York, New York: March 4, 2006

Franz Kamin

here there on on on on whole thing whole time all the time all
the time until dead all the time all the time all the time clear clear
straight move loopules loopules continuous knot continuous
knot not not knot interlacement interlacement knot interlacement
toponomadic interlacement not continuous toponomadic
interlacement not well music well helicoidal helicoidal well
helicoidal well well helicoidal you i share you i share i you
share same same different same different interlace interlacement
interlacement music moo mu moo mu interlacement music
snarl straighten comb well well break laws break rules break
day day straighten straighten no good bad bad comb bad
break break all rules laws break all rules laws music share different
lattice comb bad lattice comb snarl snarl snarl snarl snarl dead
same different different same you i you i encephaliphone you i
here dead here no go here no no music left out left out you
whiz whiz here there his whiz there homeo homeoparaleptic
i share share no brother no sister gnosis gnosis gnosis ball bosis
homeoparaleptic encounter you i you i homeoparaleptic
bosis gnosis gnosis you i different different different same well
encounter there there there there there there there not not not not
well lattice helicoidal share share there bad bad they they they they
not not not interlacement interlacement not interlacement not
they straighten straighten comb say comb say comb say make
interlacement topohomeolyptic topohomeoplyptic
together say make together no straighten straighten straighten
comb bad lattice comb snarls kill kill music kill music

snarl straighten comb well well break laws break rules break
break break all rules laws break all rules laws music share different
intertwine homeoleptic encounter homeoleptic encounter music
same different different same you i you i encephaliphone you i
homeoleptic encounter music music same same here here same
whiz whiz here there his whiz there homeo homeoparaleptic
same here here here here down down down helicoidal helicoidal
homeoparaleptic encounter you i you i homeoparaleptic encounter
well well down well well down they no they same same they
there there there there there there there there not not not not not not not
same same they same same bad lattice comb bad lattice comb no
interlacement interlacement not interlacement not interlacement
difference no difference difference you i
topohomeolyptic topohomeoplyptic topohomeoplyptic not not

not they you i you i same same intertwine same same

154

St. Paul, Minnesota: October 17, 2003

About the Author

George Quasha is a poet, artist, writer, and musician working to explore certain principles active across mediums, including language, sculpture, drawing, video, sound, and performance. His work has been exhibited in galleries and museums, including the Baumgartner Gallery (New York), Slought Foundation (Philadelphia), the Samuel Dorsky Museum of Art (SUNY New Paltz), the Snite Museum of Art (Notre Dame). His published work includes twelve books of poems, including four books of "preverbs": *Verbal Paradise, The Daimon of the Moment, Glossodelia Attract, Things Done for Themselves*; six books of writing on art, including *Axial Stones: An Art of Precarious Balance, An Art of Limina: Gary Hill's Works and Writings* (with Charles Stein); and four anthologies, including *America a Prophecy: A New Reading of American Poetry from Pre-Columbian Times to the Present,* with Jerome Rothenberg. He performs axial music solo and in collaboration with Charles Stein, David Arner, John Beaulieu, and Gary Hill. For his video project **art is/ poetry is/music is** he has recorded over a thousand artists, poets and musicians in eleven countries. Awards include a Guggenheim Fellowship in video art and a National Endowment for the Arts Fellowship in poetry. He lives with artist Susan Quasha in Barrytown, New York, where they publish books at Station Hill Press. www.quasha.com

PHOTO: SHERRY WILLIAMS

Biographical Index [page numbers in brackets]

Heide Hatry: German visual/performance/installation/book artist & curator; NYC; heidehatry.com [132]

Gary Hill: American multi-media installation artist including video & performance; Seattle, WA; garyhill.com [68]

Mikhail Horowitz: American poet, performance poet, parodist, musician, writer; Woodstock, NY; mikandgilles.com [46]

Ione: American author, playwright/director, poet; Kingston, NY; ionedreams.us [88]

Joan Jonas: American artist of video, performance, theater, sculpture; NYC/Nova Scotia, CAN; eai.org [48]

Franz Kamin: American composer, experimental performance artist, poet, writer, pianist; NYC/St. Paul, MN; wikipedia.org/wiki/Franz_Kamin [154]*

Adeena Karasick: Canadian poet, media/performance artist, essayist; NYC; adeenakarasick.com

Eva Karczag: Hungarian-Australian dance artist, teacher (dance/Alexander Technique); Arnhem, Netherlands; independentdance.co.uk [84]

Robert Kelly: American poet, playwright, writer; Annandale-on-Hudson, NY; rk-ology.com [76]

Camella DaEun Kim: Korean-Canadian media/installation/language artist; Los Angeles, CA; camelladaeunkim.com [54]

Alison Knowles: American artist of performance, radio/sound, books, installation, printmaking, Fluxus; NYC; aknowles.com [56]

Steve Kurtz: American performance artist (Critical Art Ensemble) including BioArt, electronic civil disobedience; Buffalo, NY; critical-art.net [152]

Yayoi Kusama: Japanese multi-media artist of installation & performance; novelist; Tokyo, Japan; yayoi-kusama.jp [100]

George Lewis: American composer, electronic performer, installation artist, trombone player, scholar; NYC; music.columbia.edu [58]

Chris Mann: Australian-American composer, poet, performer (compositional linguistics); NYC [98]

Joy Mboya: African performer, cultural activist; Nairobi, Kenya; artofchange.is/fellow/joy-mboya [74]

Judith Malina: German-born American theater and film actress, writer, director; NYC; livingtheatre.org [140]*

Michael McClure: American poet, playwright, songwriter, novelist; CA; michael-mcclure.com [18]

Michael Meade: American storyteller, author, mythologist, teacher; Seattle, WA; mosaicvoices.org; [86]

Jonas Mekas: Lithuanian-American filmmaker, poet & artist; Brooklyn, NY; jonasmekas.com [110]

Meredith Monk: American composer, performer, director, vocalist, filmmaker, & choreographer; NYC; meredithmonk.org [16]

Thurston Moore: American musician, singer-songwriter, poet; London, UK; thurstonmoore.com [62]

Mamta Murthy: Indian filmmaker, photographer, curator; Mumbai, India; wift.co.in/featured-profile/mamta-murthy [30]

Silvia Nakkach: Argentinian composer, performer, voice-culturist, sound artist/healer, author; Oakland, CA; wikipedia.org/wiki/Silvia_Nakkach [120]

Monica Narula: Indian multi-media performance artist, filmmaker; New Delhi, India; raqsmediacollective.net [136]

Pauline Oliveros: American composer, accordionist, electronic art musician; Kingston, NY paulineoliveros.us, deeplistening.org [60]

Eiko Otake: Japanese choreographer, dancer, movement artist, teacher; NYC; eikoandkoma.org [22]

Nilufer Ovalioglu: Turkish theater & media artist; Mardin, Turkey [108]

Rochelle Owens: American poet, playwright, video artist; Philadelphia, PA; rochelleowens.org [124]

Praxis (Brainard Carey and Delia Bajo): American & Spanish art collaborate, interactive performers; museumofnonvisibleart.com; NYC and New Haven, CT; [34]

Jerome Rothenberg: American poet, performer, translator, anthologist; Encinitas, CA; poemsandpoetics.blogspot.com [122]

Carolee Schneemann: American multidisciplinary artist of painting, film, performance art, installation, language; Tilson, NY; caroleeschneemann.com [92]

Laura Ingram Semilian: American composer, soprano, performance artist; Winston Salem, NC; laurasemilian.com [128]

Shuddhabrata Sengupta: Indian multi-media performance artist, filmmaker, writer; New Delhi, India; raqsmediacollective.net [94]

Konkona Sen Sharma: Indian actress; Mumbai, India; konkona-sen-sharma.blogspot.com; [50]

Archie Shepp: American composer, saxophonist, singer, poet, playwright; Paris, France; archieshepp.net [40]

Laetitia Sonami: French sound/performance/installation artist, composer (interactive electronic music); Oakland, CA; sonami.net [96]

Charles Stein—American poet, text/sound performance artist (glossodelia), artist (drawing), photographer, musician; Barrytown, NY; charlessteinpoet.com [130]

Richard Teitelbaum: American composer, keyboardist, improviser; Woodstock, NY; inside.bard.edu/teitelbaum [144]

Ulay (Frank Uwe Laysiepen): German performance artist, photographer, ecological art; Amsterdam & Ljubljana, Slovenia; ulay.si [114]

Victoria Vesna: Montenegrin-American digital media artist of interactive installation, researcher, science-collaborator; Los Angeles, CA; victoriavesna.com [78]

Cecilia Vicuña: Chilean poet, artist, performance artist, filmmaker, political activist; NYC and Chile; ceciliavicuna.org [44]

Monika Weiss: Polish-American artist of public performance, film/video, installation, photography, drawing; NYC; monika-weiss.com [38]

Evan Calder Williams: American essayist, performance artist, theorist; Woodstock, NY; socialismandorbarbarism.blogspot.com [102]

Peter Lamborn Wilson: American poet, writer, ontological anarchist, art-actionist; Woodstock, NY, hermetic.com/bey [90]

Robert Wilson: American experimental theater artist, director, playwright, performer, video artist; Water Mill, NY and NYC; robertwilson.com [118]

Pamela Z: American composer, experimental vocal performer, media artist; San Francisco, CA; pamelaz.com [112]

*deceased